~~PILE OF GARBAGE~~
"CREATIVE PROCESS"

tarcherperigee

An imprint of Penguin Random House LLC
375 Hudson Street
New York, New York 10014

COPYRIGHT 2017 BY ADAM J. KURTZ

TarcherPerigee with tp colophon is a registered trademark of Penguin Random House LLC.

Most TarcherPerigee books are available at special quantity discounts for bulk purchase for sales promotions, premiums, fund-raising, and educational needs. Special books or book excerpts also can be created to fit specific needs. For details, write: SpecialMarkets@penguinrandomhouse.com.

ISBN 9780143131519

Printed in Canada
10 9 8 7 6 5 4

THINGS ARE

WHAT YOU MAKE OF THEM

LIFE ADVICE FOR CREATIVES

ADAM J. KURTZ

A TarcherPerigee Book

FOR MITCHELL

THANK YOU FOR
EVERYTHING
EVERYTHING

SIMPLE TIPS FOR SUCCESS

- CONCEPT
- STRUCTURE
- ENGAGE
- BALANCE
- ENJOY
- DISTRIBUTE
- BE ~~F*****G~~ NICE
- THAT'S IT!

CONCEPT

WHAT ARE YOU EVEN DOING & WHY ARE YOU DOING IT & DOES ANYONE ELSE CARE? IS IT FOR LOVE? FOR MONEY? ATTENTION? TO FILL A VOID? SO YOU CAN STOP WONDERING "WHAT IF" BUT YOU'RE STILL NOT 100% SURE ON THE WHOLE THING? (SORRY THIS IS HARSH).

STRUCTURE

WHAT ARE THE GOALS,
OR MAYBE MORE
IMPORTANT, HOW WILL
YOU MEASURE SUCCESS?
WHAT DO YOU NEED TO
PUT IN & WHAT SHOULD
COME BACK IN RETURN?
WHEN ARE THE
DEADLINES? HOW MUCH
TIME CAN YOU SPARE?

ENGAGE

WHO ARE YOU TALKING TO & DO YOU LIKE THEM? TREAT THEM AS IF YOU LIKE THEM. TWITTER & FACEBOOK TO THEM A LOT. ALSO, ENGAGE WITH YOURSELF. ARE YOU RUNNING FULL STEAM AHEAD? WHERE IS "AHEAD"? REMEMBER THE STRUCTURE YOU'VE BUILT & KEEP CHECKING IN WITH YOURSELF.

BALANCE

ARE YOU "KEEPING IT REAL" OR NOT? PEOPLE CAN TELL WHEN YOU'RE FAKING IT, SO BE HONEST. COUNTER YOUR SHINY BRIGHT WITH A LITTLE BIT OF HUMANITY. SPEAKING OF, HOW ARE YOU? YOU THE PERSON, NOT THE BRAND. ARE YOU OKAY? GIVE YOURSELF SOME TIME TO JUST BE.

ENJOY

AT THIS POINT, IF IT'S ALL ABOUT THE MONEY, YOU PROBABLY AREN'T LOVING EVERY MINUTE. DOING A THING YOU CARE ABOUT MAKES FINDING JOY IN ALL OF THIS POSSIBLE. ARE YOU MAKING FRIENDS? NETWORKING IS KIND OF GROSS BUT MAKING FRIENDS IS AWESOME! TRY FOR THE LATTER BUT KNOW THAT YOU CAN'T BE FRIENDS WITH EVERYONE.

DISTRIBUTE

HOW'S IT GOING NOW? WITH ANY LUCK YOU'RE EARNING SOMETHING OR PRODUCING WHATEVER. BE SURE TO REWARD & CREDIT YOUR COLLAB- ORATORS. GIVE STUFF AWAY. BEING ABLE TO SHARE IS ITS OWN KIND OF REWARD. THAT SOUNDS CHEESY, BUT HONESTLY, IT FEELS GREAT.

BE ~~FUCKING~~ NICE

HOPEFULLY YOU'VE BEEN NICE ALREADY, STAYING HONEST WITH YOUR AUDIENCE, MAKING FRIENDS & SPREADING ANY LEVEL OF SUCCESS AROUND. GREAT! NOW KEEP DOING THAT. YOU NEVER KNOW WHEN OR HOW AN INTERACTION WILL SNOWBALL INTO THE NEXT COOL OPPORTUNITY.

THAT'S IT!

JUST KIDDING, NO IT
ISN'T. THERE'S NEVER
AN END. MORE CHALLENGES,
SUCCESSES & FAILURES
AWAIT. THIS WHOLE THING
MIGHT TANK. OR
SKYROCKET. OR LIFE
WILL CHANGE ENTIRELY
SOMEHOW. YOU NEVER
TOTALLY KNOW & NO
RULES ARE FOOLPROOF.
ACCEPT HELP & ADVICE,
ACCEPT WHATEVER HAPPENS
& KNOW THAT YOU CAN
LITERALLY DO ANYTHING.

NOTE FROM THE AUTHOR

Whether you're an artist, writer, designer, illustrator, musician, blogger, social media thing (???), or any other type of modern-day working creative, I hope you will find something in here to help you in both your professional practice and your personal life.

We're a type of person—a sensitive, passionate, motivated type of person—and in today's world our roles are constantly shifting and evolving. We don't always know where we fit in.

Trying to "make it work" is a choice, but often "making work" is not. It's a creative compulsion that may have snuck up on you. Sometimes we're so passionate, it can be hard to find the line between what we do and who we are. Sometimes we forget that it's okay to just live. Being alive is an accomplishment in and of itself. We don't need to make every experience into art. Breathe.

I hope that this book serves as a reminder of all the things you knew but forgot—an extra little boost for anyone embarking on, or working through, their own creative journey, wherever it takes you.

No matter what, never forget, things are what you make of them.

-Adam

ACKNOWLEDGMENTS

I acknowledge that all advice is subjective. There is no right answer or "magic solution" that works for everyone.

I acknowledge that I am not "the expert" or even "an expert" and writing this book does not change that.

I acknowledge that success is at least 50 percent timing.

I also acknowledge that "success" is an infinite, intangible concept. If you are creating something that makes you feel a little more okay and helps others, I think you've made it.

I acknowledge that we only get one body and one brain and if I don't take better care of myself I'll be totally screwed someday. I acknowledge that acknowledging this is not the same as taking concrete action.

I acknowledge that actually, there is a future and pretending otherwise will only leave me ill-prepared.

I acknowledge that ultimately I am just one person who has been, and still is, trying to figure out what they are doing.

I acknowledge that I will probably never know for sure.

THANKS

Thank you to Grace Bonney, Kelli Kehler, Jesse Vaughan, and to everyone who has read and shared any of these words. I couldn't have made this without your insight and support.

FOLLOW @ADAMJK
OR VISIT ADAMJK.COM

Photo by Daniel Seung Lee

Adam J. Kurtz is an artist and author whose illustrative work is rooted in honesty, humor, and a little darkness. His first book, *1 Page at a Time*, has been translated into fifteen languages. He's collaborated with brands and cultural institutions like Urban Outfitters, the Brooklyn Public Library, Fishs Eddy, and Strand Bookstore.

He lives in Brooklyn, New York, where he enjoys eating bread and smiling at dogs.

ALSO AVAILABLE
FROM ADAM J. KURTZ

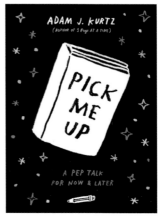

"MASTER OF THE PLAYFUL,
LIGHTWEIGHT MOOD BOOSTER."
— BUZZFEED

"BLURRING THE LINE BETWEEN
ARTIST & THERAPIST."
— VICE

"BRING A TRASH BAG OF ZOLOFT."
— FAST COMPANY

CONTENTS

FOREWORD

One of the hardest things about running your own business is finding people to talk to about your fears, insecurities, and dreams. Opening your heart and sharing your story can be scary, but they can also lead to deeper connections and important life lessons. I've seen those moments of shared vulnerability turn into lifelong friendships, new collaborations, and serious lifelines when times get tough. So I am always on the lookout for people and voices online that make me feel that sense of safety to be open and honest.

I knew I liked Adam J. Kurtz before I even met him. In a sea of online voices clamoring to be heard, his stood apart in its unrelenting honesty, clarity, and vulnerability. His openness in discussing difficult topics like depression, creative blocks, and asking for help felt like a beacon pulling me toward his posts. So I opened my laptop and wrote him an email out of the blue, asking if he'd want to come write a column for my blog, *Design*Sponge*. When he said yes, I got up and danced around the room.

When someone's voice is as singular as Adam's, you hand them the reins and let them do their thing. From Adam's very first essay, "How to Get Over Comparing Yourself to Other Creatives" it was clear he had a unique ability to talk about uncomfortable subjects in a way that made readers feel supported and safe.

Adam's column was an instant success and since his first week he's tackled, with wit and compassion, issues like getting over your fears, how to be yourself and be happier, and what to do when you fail. He's never afraid to address the topics we're all nervous to discuss openly, and because of his bravery and honesty, we get to follow his first step into an open and supportive dialogue. He speaks with a relatable blend of self-deprecating humor and confidence, always reminding us that with a laugh and some help from friends, we can get through just about anything.

Now this advice has been compiled into the very special book you have in your hands. Whether you devour them in a single sitting or slowly space them out, Adam's words will make you feel like you have a friend in him—like you belong somewhere. Instead of shying away from topics that make me feel exposed or sensitive, Adam's writing has made me feel bolder and braver to discuss these issues openly. I can't wait to dog-ear and highlight the heck out of the book, and I know you'll feel the same. Thank you, Adam, for helping all of us in your community feel connected and for reminding us that we're not alone.

—Grace Bonney

Founder of *Design*Sponge* and *New York Times* bestselling author of *In the Company of Women*

THINGS ARE
WHAT YOU MAKE
OF THEM

Whether you're contemplating a self-initiated project or embarking on new work for someone else, sometimes the hardest part comes right away. Even when it's the work you love, when it's a craft you've built a life around, just getting started can feel impossible. Sure, this is our "thing." We've made it through the initial planning, we have some sort of end goal outlined, we have a deadline, but then the actual "doing it" part is where things can slow down.

There is a creative sweet spot that kicks in when you're excited about a project, but sometimes you just can't turn it on at will. We're talking about intangibles here. Getting started can take a little bit of tricking your brain by indulging its procrastination, letting it believe it's won, all while secretly laying the groundwork to dive in and succeed. Here are some steps you can read while procrastinating (or gently share with someone who needs a small push).

HOW TO GET STARTED

- BLLEERRGHHH
- OK OK OK FINE
- WHAT ARE YOU DOING?
- BREAK IT INTO STEPS
- TAKE A NAP???
- TIME TO DIVE IN
- GET IN THE ZONE
- TAKE ANOTHER LOOK

BLLEERRGHHH

WORK IS THE WORST!!!
WHY DO WE HAVE TO
DO THIS? WHY DO WE
HAVE TO DO ANYTHING?
REMEMBER BEING A
KID & YOUR, LIKE, TOP
CONCERN WAS IF YOU
HAD A COOL LUNCH OR
WHATEVER?? THOSE
WERE THE DAYS. HMM,
ACTUALLY I COULD EAT
SOMETHING NOW MAYBE...

OK OK OK FINE

YES, ALL RIGHT, JUST HAVING WORK TO DO IS ITS OWN KIND OF PRIVILEGE. BETTER TO HAVE SOMETHING TO GET DONE THAN TO HAVE NOTHING AT ALL. SURE, LET'S START MOVING ON THIS. IF IT'S GONNA HAPPEN THEN IT MIGHT AS WELL BE AS GOOD AS POSSIBLE. START WHILE THERE'S STILL ENOUGH TIME TO THINK.

WHAT ARE YOU DOING?

HOW WILL YOU APPROACH THIS? WHETHER THERE'S A PROJECT OUTLINE OR LIST OF NEEDS OR SOMETHING, YOUR FIRST STEP IS ALWAYS GOING TO BE DECIDING HOW YOU'LL TACKLE A CHALLENGE. IS THIS BUSINESS AS USUAL FOR YOU OR A NEW TASK TO HANDLE YOUR WAY? SURPRISE! TURN YOUR PROCRASTINATING INTO PLANNING.

BREAK IT INTO STEPS

YOU KNOW WHAT FEELS HARD? A BIG, GIANT, POSSIBLY SCARY THING. NOW THAT YOU'VE GOT A PLAN OF ATTACK, SMASH THE TASK INTO MANAGE-ABLE CHUNKS THAT YOU CAN TAKE OUT A FEW AT A TIME. A LIST YOU CAN CROSS OFF OR BOXES TO TICK AS YOU GO CAN BE BOTH A USEFUL TOOL & ALSO THEIR OWN TINY, SATISFYING REWARD.

TAKE A NAP???

WELL ~~SHIT~~, NOW I'M GETTING KIND OF TIRED. AREN'T YOU TIRED FROM THAT PLANNING & LIST MAKING? IT'S LIKE A FULL-TIME JOB JUST PREPARING TO BEGIN!!! MAYBE IT'S A WEIRD WEEK FOR YOU? DON'T BEAT YOURSELF UP. BUT IF YOU DO NEED TO TAKE A LITTLE MORE TIME, KNOW THAT THIS IS IT. LAST EXCUSE & NO MORE BREAKS.

TIME TO DIVE IN

THIS IS ~~FUCKING~~ IT!! GET GOING ON YOUR LIST, COMPLETING THE STEPS YOU'VE LAID OUT FOR YOURSELF. PUT YOUR PHONE AWAY SOMEWHERE. DON'T FIDDLE WITH THE MUSIC OR AIR TEMPERATURE OR WHATEVER OTHER BULL~~SHIT~~ YOU'RE THINKING ABOUT. THIS IS THE REAL THING & WE ARE NOT PLAYING AROUND ANYMORE!

GET IN THE ZONE

AFTER A FEW STEPS,
IT'S ALL COMING BACK
TO YOU. YOU'RE IN THAT
HEADSPACE WHERE YOU
KNOW WHAT YOU'RE DOING
& HOW TO DO IT & EVERY-
THING ELSE SORT OF
FADES AWAY. YOUR COFFEE
IS COLD. YOUR WATER'S
WARM. THE MUSIC IS
LOOPING & YOU DON'T
CARE. THIS IS THAT
CREATIVE SWEET SPOT &
YOU TRICKED YOURSELF
INTO GETTING HERE.

TAKE A ~~FINAL~~ NOTHER LOOK

HA HA HA WE ALL KNOW THE END IS NEVER THE END. MORE LIKE "FINISH LINE V2_FINAL_FINAL" BY THE TIME YOU GET THERE. SO TAKE A STEP BACK & COMPARE YOUR OUTPUT WITH YOUR LIST, YOUR GOAL, THE CLIENT'S OR PROJECT'S ORIGINAL NEEDS & PATCH UP ANY WEIRD GAPS. STARTING WAS THE HARD PART BUT YOU'RE CLOSE NOW...

YOU CAN DO THIS.

There are plenty of tips and anecdotes and case studies and advice for "creatives" out there. A lot of it is very good stuff, but sometimes it feels like too much to digest.

Let's focus on some base elements. Eight simple, maybe obvious things that are worth remembering. If you can look past this oversimplified title–"#5 Made Me Laugh 'Til I Cried!"–one or all of these might be an important reminder for right now.

As for what a "creative" even is? That's a whole other conversation. For now, let's assume it's you, a person who defines themselves, in some way, by their creative passion or profession.

8 THINGS EVERY CREATIVE SHOULD KNOW

- IT'S MAGICAL, NOT MAGIC
- YOU ARE KIND OF AN IDIOT
- YOU DON'T NEED PERMISSION
- FAILURE ACTUALLY IS AN OPTION
- LABELS WILL KILL YOU
- YOU DON'T HAVE TO BE THE BEST AT EVERYTHING
- YOU WILL HATE YOUR WORK
- JUST BE NICE

IT'S MAGICAL, NOT MAGIC

CREATIVITY IS SORT OF A CATCH-ALL IDEA THAT ENCOMPASSES SO MANY THINGS. IT'S HARD TO NAIL DOWN, BUT YOU KNOW IT WHEN YOU SEE IT. ONE THING IT ISN'T IS A SUPERPOWER YOU'RE JUST BORN WITH. IT'S NOT EXCLUSIVE. ANYONE CAN TAP INTO THEIR CREATIVE ENERGY TO MAKE SOMETHING SPECIAL WITH HARD WORK & A LITTLE BIT OF LUCK.

YOU ARE KIND OF AN IDIOT

NOBODY KNOWS WHAT THE F**** THEY ARE DOING & THAT IS TOTALLY OKAY. SO MUCH OF WHAT WE DO IS LEARNED ON THE JOB, AS WE TACKLE NEW PROJECTS OR ENCOUNTER NEW PERSPECTIVES. EVERYONE HAD TO START SOMEWHERE & EVERYONE IS CONSTANTLY LEARNING MORE. YOU ARE KIND OF AN IDIOT BUT IT'S GOING TO BE OKAY.

YOU DON'T NEED PERMISSION

THE INTERNET HAS GIVEN US UNLIMITED RESOURCES IN TERMS OF LEARNING, SOFTWARE & PRODUCTION. WE NO LONGER NEED TO WAIT FOR THE GREEN LIGHT FROM INDUSTRY GATE-KEEPERS. WITH A BIT OF DIGGING YOU CAN DESIGN & EXECUTE THE PROJECTS YOU WANT TO SEE IN THE WORLD, DISTRIBUTE THEM & WATCH THEM FLOURISH.

FAILURE ACTUALLY IS AN OPTION

UMM, FAILURE IS TOTALLY AN OPTION. IT'S ACTUALLY ONE OF TWO MAIN OPTIONS IN MOST SCENARIOS. INSTEAD OF LYING TO YOURSELF ABOUT THE POSSIBILITIES, CHOOSE INSTEAD TO BRACE YOURSELF FOR ANY OUTCOME & BE READY TO LEARN FROM THE EXPERIENCE. YOUR CREATIVE LIFE IS A JOURNEY & EVERY STEP IS MOVING YOU FORWARD.

LABELS WILL KILL YOU

YOU MAY FEEL TREMENDOUS PRESSURE TO ASSIGN YOUR- SELF A LABEL OR ALIGN WITH A CRAFT, BUT THE TRUTH IS THAT MOST OF US DO A LOT OF DIFFERENT THINGS. MAYBE MAKE A BUNCH OF WORK TO FIGURE OUT WHAT YOU'RE BEST AT BEFORE BRANDING YOURSELF IN A SINGLE ROLE THAT LIMITS POSSIBLE OPPORTUNITIES THAT MAY COME AS YOU GROW.

YOU DON'T HAVE TO BE THE BEST AT EVERYTHING

YOU MIGHT BE ~~FUCKING~~ AMAZING BUT YOU'LL STILL NEVER BE THE BEST AT EVERY-THING. THIS ISN'T WEAKNESS, IT'S SELF-AWARENESS. ASSESS YOUR STRONG POINTS & THEN COLLABORATE WITH OR HIRE PEOPLE WHO EXCEL AT WHAT YOU ARE MERELY ADEQUATE AT. GROW TOGETHER WHILE DOING WHAT YOU ACTUALLY LOVE.

YOU WILL HATE YOUR WORK

DO YOU EVER LIE AWAKE AT NIGHT AGONIZING OVER S̶█̶█̶█̶ YOU DID YEARS BEFORE? SIMILARLY, YOU WILL LOOK BACK AT PREVIOUS WORK & CRINGE. RESPECT YOUR GROWTH PROCESS & RECOGNIZE THAT AS YOU LEARN, WHAT WAS ONCE YOUR ABSOLUTE BEST WILL FEEL AMATEURISH. YOU WILL FIND NEW APPROACHES TO OLD PROBLEMS & THAT IS SOMETHING TO BE PROUD OF.

JUST BE NICE

YOU KNOW HOW HARD ~~SHIT~~ IS,
SO YOU KNOW WHAT EVERYONE
ELSE IS DEALING WITH
TOO. YOU ARE NOT IN COMPE-
TITION WITH EVERYBODY ELSE.
YOU ARE UNIQUE, SO FOCUS ON
BEING THE RESPECTFUL &
(GENERALLY) POSITIVE VERSION
OF YOURSELF THAT PEOPLE
CHOOSE TO WORK WITH, TRUST
& HELP ALONG THE WAY.

BEING GENUINELY KIND IS
NOT A SIGN OF WEAKNESS.

If you think about it long enough, pretty much everything is a little terrifying, right? Our brains and bodies are built to protect us and they've got to remain on high alert as life teaches us what to stop worrying about. Are carrots safe? Yeah! Touching a hot stove? Nope. A first date? Probably. A job interview? We'll see…

Though we're all learning to conquer our individual challenges, there are some fears that probably ring true for all of us. These are some of those fears, and we're going to get over them together. Maybe.

HOW TO GET OVER COMMON CREATIVE FEARS (MAYBE)

- ACKNOWLEDGE FEAR
- BREAK IT DOWN
- "I CAN'T DO THIS"
- "NOBODY CARES"
- "IT'S NOT PERFECT"
- "I'M TOO _____"
- "WHAT'S THE POINT?"
- LAUGH

ACKNOWLEDGE FEAR

MAKING SOMETHING & SENDING IT OUT INTO THE WORLD IS TERRIFYING. RELYING ON YOUR PASSION TO MAKE A LIVING IS TERRIFYING. EMBRACE THAT YOUR FEAR DOESN'T MAKE YOU WEAK, IT MAKES YOU HUMAN. NOW FACE IT HEAD ON:

BREAK IT DOWN

WHAT IS THIS FEAR TELLING YOU? WHAT ARE YOU REEEAALLY FEELING? AS CREATIVES, WE'RE ALWAYS SOLVING PROBLEMS IN NEW WAYS. SO WHAT THE ~~FUCK~~ IS YOUR PROBLEM?? FIGURE IT OUT SO YOU CAN FIND A SOLUTION!

"I CAN'T DO THIS"

THIS MIGHT BE THE MOST BASIC OF ALL FEARS? ALSO THE EASIEST TO CONQUER. HOW DO YOU KNOW YOU CAN'T DO IT IF YOU HAVEN'T ACTUALLY, FULLY TRIED? YOU CAN'T WIN A RACE YOU DON'T RUN & IT'S NOT REALLY RUNNING IF YOU DIDN'T TRAIN BEFORE-HAND. MAYBE TRY TRYING.

"NOBODY CARES"

IT'S EASY TO FEEL LIKE NOBODY CARES WHEN YOU LIVE IN THE BUBBLE OF YOUR OWN INDUSTRY. WE GET SO WRAPPED UP IN OUR "THING" THAT WE FORGET THAT TO OTHERS, WHO ARE DOING TOTALLY DIFFERENT THINGS WITH THEIR LIVES, THE S▪▪▪ WE DO EVERY DAY IS FOREIGN & WONDERFUL.

"IT'S NOT PERFECT"

IT'S HARD TO LET GO
OF A PROJECT THAT
FEELS IMPERFECT.
BUT NOT ONLY IS
"PERFECTION" NON-
EXISTENT, YOUR CURRENT
PERFECT WILL ONE DAY
BE YOUR "MEH" AS YOU
CONTINUE TO GROW YOUR
CRAFT. BASICALLY, DO
YOUR BEST & THEN SHUT
UP & LET PEOPLE
LOVE IT.

"I'M TOO _____"

REALLY? THAT'S THE FEAR WE'RE GOING WITH? YOU COULD LET THIS RULE YOUR ENTIRE LIFE, BUT IF WE'VE LEARNED ANYTHING SINCE HIGH SCHOOL, IT'S THAT WHAT DOESN'T WORK IN ONE PLACE IS EXACTLY RIGHT IN ANOTHER. LET YOUR WORK SPEAK FOR ITSELF.

"WHAT'S THE POINT?"

REMEMBER THAT THE
REASON WE DO WHAT
WE DO, THAT WE'RE
CARVING OUR OWN
PATH, IS BECAUSE WE
HAVE A DEEP-ROOTED
NEED TO CONNECT &
THIS IS HOW WE DO IT.
IF YOU'RE LOSING SIGHT
OF THE POINT, OR JUST
FEELING A LITTLE DULL,
TAKE SOME TIME TO
SHARPEN & YOU'LL BE
AS GOOD AS NEW.

LAUGH

IF ALL ELSE FAILS, TRY COMBATING FEAR WITH HUMOR. LIKE A GOOD CRY, A GOOD LAUGH CAN BE A GREAT RELEASE. HA. EVERYTHING IS TERRIFYING BUT YOU ARE GOING TO BE OKAY.

Part of doing your own thing is figuring out where to work. Whether you have a dedicated home office or a coffee table in the living room, the hardest part of working from home is actually getting the work done, and without going crazy.

So how do you achieve balance when you're in the same space all day and night? I'm still not 100 percent sure, but I do have a few tips.

HOW TO STAY SANE WHEN YOU WORK FROM HOME

- PUT ON SOCKS
- GET SOMETHING
- WARM UP
- OKAY DO IT
- REAL LUNCH BREAK
- WORK TOGETHER
- END OF DAY
- GO NUTS

PUT ON SOCKS

JUST BECAUSE YOU
DON'T NEED TO GET
DRESSED DOESN'T
MEAN YOU SHOULDN'T.
PUTTING ON SOCKS
& MAYBE EVEN
SHOES PROVES
(TO YOURSELF)
THAT YOU MEAN
BUSINESS.

GET SOMETHING

LEAVE HOME FOR ANY REASON. GET A COFFEE, GRAB THE NEWSPAPER, OR GO FOR A BRIEF WALK. IT'S NOT A "COMMUTE" BUT THE SEPARATION WILL HELP.

WARM UP

NOW IT'S TIME TO START. WARM UP BY REPLYING TO EMAILS OR MAKING/SHARING SOMETHING ON SOCIAL MEDIA. EASE INTO YOUR WORKDAY AS YOUR HOME STARTS TO FEEL LIKE YOUR OFFICE.

OKAY, DO IT

TIME TO WORK.
NOT IN YOUR BED,
IN YOUR OFFICE.
THAT MIGHT JUST
BE THE COUCH, BUT
IT CANNOT BE
YOUR BED. CREATE
A HEALTHY
BOUNDARY TO
STAY SANE.

REAL LUNCH BREAK

EAT LUNCH, EVEN
IF THAT JUST MEANS
THE BREAKFAST YOU
DIDN'T HAVE WITH
COFFEE. EAT IT
ANYWHERE BUT YOUR
WORK SPACE.
MAYBE EVEN WITH
ANOTHER PERSON!!!

WORK TOGETHER

IF WORKING AT A CAFE ALONE FEELS IMPOSSIBLE, INVITE A FRIEND. IGNORING A FRIEND CAN BE A GREAT MOTIVATOR!! IF YOU HAVE A BIG HOME STUDIO (OR KITCHEN TABLE) INVITE THEM OVER. THEY COULD USE A CHANGE TOO.

END OF DAY

HAVE A DEFINED END OF THE WORK DAY. IT MIGHT FLUCTUATE OR YOU MIGHT HAVE TO WORK "OVERTIME," BUT THIS MENTAL SEPARATION CAN MAKE A HUGE DIFFERENCE.

GO NUTS

JUST KIDDING!!
WORKING FROM
HOME SUCKS HALF
THE TIME NO MATTER
WHAT. BUT THAT
OTHER HALF? YOU'RE
~~FUCKING~~ FREE!
ENJOY NOT BEING
NICE TO SMUG JERKS
& PLAYING YOUR
MUSIC ALOUD.
YOU ARE PRETTY
LUCKY OVERALL.

We know we shouldn't, but we compare ourselves to others constantly. Maybe we're telling ourselves it's healthy competition and beneficial to our work. More likely we know it's just making us miserable. Whether you're deluding yourself or not, I'm here to tell you it's bad. Stop doing it.

I've created a simple guide to finally put an end to this bad habit *and* find something positive in the process. Today's the day. We can do this together.

HOW TO GET OVER COMPARING YOURSELF TO OTHER CREATIVES

- ADMIT IT
- REFLECT
- COUNT YOUR BLESSINGS
- FEEL PRIDE
- CELEBRATE
- FIND INSPIRATION
- MAKE NEW WORK
- RIP OUT YOUR EYEBALLS

ADMIT IT

LET'S JUST SKIP TO THE FINAL STAGE OF GRIEF, OKAY? ACCEPT THAT YOU COMPARE YOURSELF TO OTHERS. YOU GET A LITTLE BIT JEALOUS, THOUGH YOU KNOW BETTER. PEOPLE ARE GETTING CONTRACTS, INVESTMENTS, FOLLOWERS & ENDORSEMENTS. YOU HAVE NOTICED.

REFLECT

SO YOU DO IT. FINE! SO
WHAT? IS IT DESTROYING
YOU, OR MERELY A
NAGGING FEELING?
DOES OTHER PEOPLE'S
SUCCESS INFORM OR
MOTIVATE YOUR ACTIONS?
HOW IS THIS AFFECTING
YOU? CONSIDER ALL
OF THIS. COMMIT TO
STOPPING IT AS BEST
AS YOU CAN.

COUNT YOUR BLESSINGS

SHE HAS THIS & THEY HAVE THAT, BUT WHAT DO YOU HAVE? TAKE STOCK OF YOUR PROFESSIONAL & PERSONAL ACHIEVEMENTS. YOU HAVE GREAT THINGS! YOU ARE ON YOUR WAY! YOU ARE SO GOOD! YOU ARE ~~FUCKING~~ DOING IT!

FEEL PRIDE

ALLOW YOURSELF TO ENJOY YOUR OWN SUCCESS. IT'S SO COOL THAT YOUR THING IS HAPPENING! FEEL PROUD THAT YOUR PEERS OR COLLEAGUES ARE FINDING SUCCESS. DON'T BE JEALOUS, BE PROUD THAT WHAT YOU ALL OFFER IS CLEARLY MARKETABLE, DESIRABLE & GARNERING RECOGNITION.

CELEBRATE

THIS ONE IS HARDER TO FAKE, SO HOPEFULLY YOU MEAN IT BY NOW. JOIN IN ANY CELEBRATION FOR YOUR PEERS! ATTEND THE POP-UP OR TOAST OR MARKET OR MEET-UP OR OPEN HOUSE. BE SUPPORTIVE & GENUINE— SUCCESS & JOY ARE CONTAGIOUS!

FIND INSPIRATION

YOU'RE AWARE OF WHAT OTHERS ARE DOING & NOW YOU'RE CELEBRATING WITH THEM. A HEALTHY EXCHANGE IS GUARANTEED TO INSPIRE NEW IDEAS. MAYBE THIS TAKES THE FORM OF A COLLABORATION OR A WELL-TIMED CONVERSATION TRIGGERS SOMETHING NEW.

MAKE NEW WORK

ONE POSITIVE TO BEING
AWARE OF WHAT OTHERS
ARE DOING IS BEING
AWARE OF WHAT THEY
AREN'T DOING. LET YOUR
INSPIRATION & ANECDOTAL
RESEARCH LEAD YOU TO
TOWARD PROJECTS &
WORK THAT FILL THE
GAPS YOU'VE NOTICED.
OFFER SOMETHING THAT
DOESN'T EXIST YET.

RIP OUT YOUR EYEBALLS!!!

IF ALL ELSE FAILS, STOP LOOKING! TAKE A BREAK FROM OBSESSIVELY CHECKING FOLLOWER COUNTS OR CLIENT ROSTERS. LOOK INWARD INSTEAD. WHAT ARE YOU WORKING ON NOW? NEW BUSINESS? PERSONAL PROJECTS? EVERYONE SHARES THEIR BEST SELF. BE MORE OF YOUR OWN BEST.

Sometimes the hardest thing in life (other than that whole "being alive" thing) is being happy. Everyone is trying to find happiness or stay happy in any way they can. We all have some idea of what it feels like, and yet, if we're such experts on being happy, why are we not just doing it constantly?

There is no BIG SECRET THAT EVERYONE EXCEPT YOU KNOWS, although it can sometimes feel that way. For the most part we actually know these basic, common truths; we just forget them when it matters most. This is our reminder.

HOW TO BE HAPPY ~~HAPPY~~ HAPPIER

- EMBRACE YOURSELF
- ACKNOWLEDGE THE SAD
- CREATE & MEET GOALS
- FIND FRESH INSPIRATION
- SUNSHINE & RAINBOWS
- CELEBRATE EVERYTHING
- FEEL CONTENT
- FORGET THE "DESTINATION"

EMBRACE YOURSELF

LIFE IS CONSTANTLY REMINDING US ABOUT WHAT WE DON'T HAVE, BUT WHAT ABOUT ALL THAT WE DO HAVE? WHAT MAKES YOU SPECIAL? WHAT DO YOU HAVE TO OFFER THE WORLD AROUND YOU? WHAT DO YOU ENJOY? FIND THE THINGS THAT YOU DO LOVE ABOUT YOURSELF.

THEY'RE ENOUGH.

ACKNOWLEDGE THE SAD

HIDING YOUR DARKEST
FEELINGS FROM STRANGERS
IS PROBABLY SMART???
HIDING THEM FROM YOUR-
SELF IS NOT. RECOGNIZE
WHAT IS HURTING YOU.
TAKE STEPS TO ADDRESS IT.
THIS MIGHT MEAN TALKING
TO SOMEBODY WHO
UNDERSTANDS. THIS MIGHT
MEAN TAKING REAL
 TIME TO PROCESS.

CREATE & MEET GOALS

HAVING SOMETHING POSITIVE TO LOOK FORWARD TO IS IMPORTANT. WE NO LONGER HAVE THE STRUCTURE OF CHILDHOOD TO KEEP US MOTIVATED & SUBSEQUENTLY REWARDED. SO SET GOALS FOR YOURSELF, BIG OR SMALL. THEN MEET THEM. THEN SET NEW ONES & KEEP ON GOING (FOREVER).

FIND FRESH INSPIRATION

"YOUR THING" CAN START TO FEEL LIKE THE "ONLY THING," BUT THERE'S JUST SO MUCH TO EXPERIENCE, LEARN, OR INVEST IN. THIS DOESN'T MEAN A CAREER CHANGE, IT'S JUST NICE TO REMEMBER THE WORLD HAS PLENTY TO OFFER. TRAVEL MORE, READ MORE, LEARN NEW SKILLS & TRY NEW THINGS.

SUNSHINE & RAINBOWS

IT'S NOT ALL SUNSHINE &
RAINBOWS, BUT A LOT OF
IT ACTUALLY IS! SUNSHINE
IS LITERALLY GOOD FOR YOU,
SO GO SOAK UP THAT
VITAMIN D. THE SUN IS A
MASSIVE STAR THAT WILL
OUTLIVE ALL OF US. AS FOR
RAINBOWS, WELL, YOU'VE
GOT TO WEATHER THE
STORM FIRST.

HANG IN THERE.

CELEBRATE EVERYTHING

THE THINGS YOU TAKE FOR GRANTED MIGHT BE MAJOR ACCOMPLISHMENTS FOR SOMEONE ELSE. PAYING RENT ON TIME IS AN ACCOMPLISHMENT. GETTING ERRANDS DONE IS AN ACCOMPLISHMENT. EVEN JUST WAKING UP IS AN ACCOMPLISHMENT WORTH CELEBRATING (POSSIBLY WITH COFFEE).

FEEL CONTENT

NOBODY GETS EVERYTHING
THEY WANT. THERE WILL
ALWAYS BE SOMETHING.
NEW PROBLEMS ARISE.
INSTEAD OF STRIVING FOR
PERFECTION, STRIVE FOR
CONTENTEDNESS. FIND
A WAY TO BE HAPPY WITH
WHAT YOU ALREADY HAVE
& YOU'LL ALWAYS HAVE
EXACTLY WHAT YOU
NEED.

FORGET THE "DESTINATION"

YOU DON'T EVEN NEED
THIS ONE BUT HERE IT
GOES ANYWAY!!!!!!!!!!
HAPPINESS IS NOT A PLACE,
IT IS A JOURNEY. YOU DO
NOT "ARRIVE" AT JOY, BUT
YOU CAN STRIVE TO CREATE
IT IN SMALL & ENJOYABLE
WAYS. STOP SEARCHING
FOR THE END OR IT'LL FIND
YOU BEFORE YOU EVER
"GET THERE."

Every person has power and a unique set of skills for putting it to work. Whether your talent is rooted in words, images, organization, persuasion, or building an audience, the things you do in your daily life are your way to tap into your innate, raw power and use it for good.

Part of recognizing this ability is acknowledging your obligation to use it to stand up for what's right. There's so much in the world that needs our attention. Some things could simply benefit from a little compassion. Other issues are more complex and require deliberate steps toward change. You have the ability to create impact of some kind. Remember that when your power is specifically rooted in communication, your silence speaks volumes.

You have the power and tools to create positive change. Put them to good use.

USING YOUR POWER FOR GOOD

- FOCUS YOUR POWER
- COMMUNICATION IS A GIFT
- BE HONEST
- DEFINE YOUR GOAL
- EMBRACE COMMUNITY
- WORK TOGETHER
- IT IS IN YOU!!!!
- EVERY BIT COUNTS

FOCUS YOUR POWER

YOU HAVE TOOLS & EXPERIENCE, SO WHAT WILL YOU DO WITH THEM? ARE YOU A STRONG WRITER? DO YOU HAVE AN AUDIENCE TO TAP INTO? HOW DO YOU COMMUNICATE BEST & HOW CAN YOU USE THAT SKILL NOW, FOR GOOD?

LOOK FOR NEW & USEFUL WAYS TO HARNESS WHAT YOU DO BEST.

COMMUNICATION IS A GIFT

AS CREATIVES, WE ARE TAPPED INTO SPECIFIC METHODS FOR SPREADING IDEAS. FROM VERBAL TO VISUAL, DIRECT TO SUBTLE, THE ABILITY TO COMMUNICATE IS A GIFT. USE YOUR TOOLS TO SAY IT LIKE IT IS, OR CHOOSE TO CREATE A MOOD OR ENERGY THAT LETS OTHERS PUT THE PIECES TOGETHER.

BE HONEST

IS THIS ACTION FUELED BY PASSION & CREATIVE NEED, OR IS YOUR MOTIVATION TO ATTRACT ATTENTION FOR YOURSELF? BOTH KINDS OF PERSONAL WORK HAVE MERIT, BUT WHEN IT COMES TO SOCIAL OR POLITICAL CAUSES, THE LATTER CAN UNDERMINE YOUR EFFORT & YOU KNOW, FEEL JUST A BIT DISINGENUOUS.

DEFINE YOUR GOAL

IT'S NAIVE TO ASSUME YOU'RE GOING TO FIX THE WORLD, BUT IT CAN BE HELPFUL TO DEFINE A GOAL. WHAT'S YOUR DESIRED OUTCOME? AWARENESS? SOLIDARITY? PROVIDING A RESOURCE? PERSONAL CATHARSIS? MAKE SURE THAT THE POWER & PASSION YOU'RE HARNESSING HAS A PURPOSE, NO MATTER HOW SMALL.

EMBRACE COMMUNITY

WHEN RESPONDING TO
SOMETHING WITH YOUR
CREATIVE ENERGY, IT'S
TEMPTING TO WANT TO DO
IT ENTIRELY YOUR WAY.
REMEMBER THAT YOU DO
NOT "OWN" ANY CAUSE.
SEARCH FOR EXISTING
WORK & RESOURCES.
LOOK TO THE COMMUNITY
TO SEE WHAT YOU CAN
ADD, INSTEAD OF TRYING
TO SHOUT LOUDER.

WORK TOGETHER

BATTLES ARE RARELY
WON ALONE. INSTEAD,
IMAGINE WHAT CAN BE
ACCOMPLISHED WHEN
MANY POWERS COMBINE!
WORK WITH OTHERS TO
EXTEND YOUR COLLECTIVE
REACH, RAISE OTHER
VOICES WITH YOUR OWN
& REMEMBER THAT A
SHARED GOAL IS ABOUT
MORE THAN ANY
ONE PERSON.

IT IS IN YOU!!!!

WE MAY FORGET SOME-TIMES, BUT OUR ABILITY TO ACT & HAVE IMPACT IS MAGICAL. YOU ARE BOTH A TOOL & A WEAPON WITH THE ABILITY TO CHOOSE HOW TO WIELD YOURSELF IN EVERY SITUATION. THE CONTINUED ACT OF EXISTING IS AN ONGOING MANIFESTATION OF THIS POWER.

EVERY BIT COUNTS

YOUR CONTRIBUTION MAY NOT BE THE GROUND-BREAKING "MAGIC CURE" OR FIX. CHANGE TAKES TIME & ENERGY FROM MANY SOURCES. IT MAY BE HARD TO SEE THE IMPACT OF YOUR WORK TODAY, BUT IF EVEN ONE PERSON HAS BEEN POSITIVELY AFFECTED, EMPOWERED, OR REASSURED, YOU'VE DONE SOME GOOD.

A lot of smart people talk about failure in the creative process and I want to be smart too, so here's my take. Obviously this advice is entirely hypothetical, because I have never felt useless, crumpled up my paper halfway through a sentence, or been tempted to write a passive-aggressive email.

"Failing" as a badge of honor doesn't make sense to me. There's no need to polish this turd. Failing sucks. But failure can also bring so much to learn about ourselves, our work, and our presentation.

Success is about so much more than just talent or the merit of our ideas. Timing is everything. Connecting with the right person matters. So you take failure in stride, take whatever lesson from the experience you can, and do your best to not let the gut emotional reaction drag you down.

WHAT TO DO
WHEN YOU FAIL

- PAUSE IMMEDIATELY
- FEEL LIKE ~~SHIT~~
- REASSESS YOUR WORK
- PROCESS ANY FEEDBACK
- SEEK ADVICE
- MAKE ADJUSTMENTS
- PLAN YOUR ATTACK
- TRY AGAIN??

PAUSE IMMEDIATELY

STOP EVERYTHING.
IN THE FIRST MOMENTS
OF, YOU KNOW, NOT-SUCCESS,
IT IS A NORMAL HUMAN
REACTION TO BE HURT.
YOU MAY FEEL LIKE
DOING SOMETHING YOU
WILL REGRET. DO NOT DO
THAT THING. AVOID
BURNING BRIDGES OR
YOU'LL JUST HAVE TO
REBUILD THEM LATER.

FEEL LIKE ~~SHIT~~

FAILURE SUCKS. WE
ALL WANT TO SUCCEED
ON THE FIRST TRY, BE
THE BEST & INSTANTLY
WIN. BUT LIFE DOESN'T
WORK THAT WAY,
INSTEAD OF BLAMING
YOURSELF OR OTHERS,
JUST KNOW THAT GREAT
THINGS TAKE TIME.
FEEL A LITTLE ~~SALTY~~
BUT GET MENTALLY READY
TO MOVE FORWARD.

REASSESS YOUR WORK

EVEN IF YOU DID YOUR BEST, THERE IS ALWAYS ROOM TO IMPROVE & ADJUST TO BETTER MEET THE CHALLENGE AT HAND. MAYBE YOU WEREN'T THE RIGHT FIT THIS TIME? MAYBE THE TIMING IS JUST A BIT OFF? FOCUS ON HOW TO MAKE THINGS THAT MUCH BETTER.

PROCESS ANY FEEDBACK

IN SOME CASES, THERE ARE REFLECTIONS OR REVIEW NOTES ATTACHED. DON'T OBSESS OVER THIS CRITIQUE, BUT DO THINK ABOUT HOW IT MIGHT APPLY TO YOUR SITUATION. SOMETIMES THIS FAILURE NOW ENDS UP BEING MORE VALUABLE IN THE LONG RUN FOR WHEN IT REEEEEALLY COUNTS.

SEEK ADVICE

YOUR FRIENDS & PEERS MAY HAVE ADDITIONAL INSIGHT FOR YOU. THIS WILL BE KINDER THAN REJECTION FEEDBACK & YOU CAN SEEK TARGETED THOUGHTS ON HOW TO ADJUST FOR THE FUTURE. TRY TO IDENTIFY SPECIFIC ELEMENTS TO ASK ABOUT RATHER THAN A "HEY UHH HOW DO I FIX THIS?" EMAIL.

MAKE ADJUSTMENTS

WHICH PARTS DO YOU KNOW HAVE BEEN GREAT ALL ALONG & WHICH WOULD BENEFIT FROM ADJUSTMENT OR A LITTLE REPOSITIONING? TAKE IT ALL INTO ACCOUNT— INITIAL COMMENTS, OUTSIDE ADVICE, YOUR OWN THINKING IN THE TIME SINCE INITIAL FAILURE— & MAKE CHANGES TO REFLECT ALL THAT.

PLAN YOUR ATTACK

SUCCESS IS ABOUT SO MUCH MORE THAN WORK OR TALENT ALONE.
THINK ABOUT HOW TO NEXT SUBMIT, APPLY, OR PRESENT YOUR WORK.
PLAN A COURSE OF ACTION USING WHAT YOU NOW KNOW ABOUT WHAT YOU HAVE TO OFFER & WHO MIGHT MOST APPRECIATE OR BENEFIT FROM IT.

TRY AGAIN???

SUBMIT YOUR NEW RESUME. PRESENT YOUR ADJUSTED PRODUCT. PITCH YOUR REVISED CONCEPTS. YOU KNEW YOU HAD SOMETHING GREAT, IT JUST NEEDED SOME FINE-TUNING. OR MAYBE YOU'VE BEEN INSPIRED TO MOVE ON TO SOMETHING ELSE ALTOGETHER? FOLLOW YOUR GUT & KEEP GOING.

A fresh start can come at any time, in any way. It might be a nagging feeling that you can't ignore anymore, or a major life event may force you to rethink things all at once.

Regardless of when, how, or why, it's never too late to begin again. You can embark on a new challenge, redirect an existing focus, or come back to a passion that you abandoned years ago.

It won't be easy, and it may be a little terrifying, but you can do it.

HOW TO BEGIN AGAIN

- DON'T LOOK BACK IN ANGER
- CHECK YOUR PULSE
- DO YOUR RESEARCH
- RETOOL YOUR PRACTICE
- BE ACCOUNTABLE
- WRITE YOUR MANIFESTO
- DISAPPEAR (WITH INTENT)
- CHARGE FORWARD

DON'T LOOK BACK IN ANGER

IT'S NEVER TOO LATE TO BEGIN AGAIN & THERE ARE MANY REASONS WHY WE MAY NEED OR WANT TO. BUT ONE THING YOU CAN'T DO IS RESENT YOUR PAST. SURE, SOME OF IT WAS ~~SHIT~~. BUT YOU LEARNED. YOU GREW. YOU ARE WHO YOU ARE BECAUSE OF WHAT YOU KNOW NOW.

CHECK YOUR PULSE

WHAT DO YOU CARE ABOUT? WHERE DOES YOUR PASSION LIE? OUR MOTIVATIONS SHIFT & CHANGE AS WE DO, SO IT MAY BE RADICALLY DIFFERENT. KNOWING WHAT STOPPED BEING IMPORTANT TO YOU WAS HOW YOU GOT HERE. IT'S TIME TO IDENTIFY WHAT MATTERS NOW.

DO YOUR RESEARCH

WHILE YOU WERE OUT THERE CHANGING, SO WAS THE INDUSTRY (& THE WORLD). WHAT ARE TRENDS LIKE NOW? WHAT CAN YOU OFFER THAT YOU DON'T SEE REPRESENTED? HOW ARE PEOPLE IN ADJACENT SPACES OPERATING? LEARN AS MUCH AS YOU CAN.

RETOOL YOUR PRACTICE

NEW RESOURCES ARE LIKELY AVAILABLE NOW THAT WEREN'T THEN. ARM YOURSELF WITH TOOLS THAT YOU MIGHT NOT HAVE HAD THE FIRST TIME. WHAT IS ESSENTIAL? WHAT SAVES TIME? WHAT NOW EASILY SOLVES A PROBLEM YOU ONCE HAD? START WITH WHAT YOU REALLY NEED.

BE ACCOUNTABLE

TOUGH LOVE TIME:
SOMETIMES, SOME OF US,
MAYBE, POSSIBLY, TALK
ABOUT DOING THINGS
& THEN DON'T DO THEM.
HOLD YOURSELF ACCOUNT-
ABLE FOR YOUR FRESH
START. DON'T LET
PLANNING THE THING
TRICK YOUR BRAIN INTO
THINKING YOU'VE DONE
IT. TRY TRYING??

WRITE YOUR MANIFESTO

ONE HUGE STEP IN ACCOUNTABILITY IS WRITING THINGS DOWN TO MAKE THEM REAL. THIS MIGHT BE A STICKY NOTE OR IT MAY BE A TRADITIONAL BUSINESS PLAN. REGARD- LESS OF WHAT YOU'RE DOING, WRITE SOMETHING DOWN THAT YOU CAN'T IGNORE.

DISAPPEAR (WITH INTENT)

NOBODY ACTUALLY REINVENTS THEMSELVES OVERNIGHT. THERE ISN'T A MAGIC SWITCH. YOU'RE ALREADY OUT OF THE GAME, MIGHT AS WELL TAKE THE TIME YOU NEED TO CATCH YOUR BREATH. PLAN YOUR NEXT STEPS. PUT ALL THE PIECES TOGETHER.

CHARGE FORWARD

EVERYTHING IS A LITTLE BIT TERRIFYING WHEN YOU THINK ABOUT IT TOO LONG, SO AFTER PREPARING AS BEST YOU CAN, IT'S TIME TO JUST GO FOR IT. RUN INTO THE DARKNESS WITH YOUR MAP, YOUR NEW FLASHLIGHT & THE DESTINATION YOU'VE SET SIGHTS ON.
GO GET 'EM!!!

We turn to our friends and family for help all the time, so it should come as no surprise when they look to us for help with the things we do best. Build websites? You are now IT for your extended family. Love hand-lettering? Here are 300 wedding invitations to address. What might be a perfect personality match may not quite translate to an easy business transaction. Small favors have a tendency to balloon into something more. Unpaid favors are pushed further and further down the priority list. Feelings get hurt.

It's tricky to navigate working with friends and family, so many of us try to avoid it entirely. But there's no reason you can't do something great with someone you love as long as you take care to respect each other, communicate ideas without making assumptions, and enter into a balanced agreement from the start.

WORKING WITH FRIENDS & FAMILY

- BE HUMAN
- SET CLEAR BOUNDARIES
- ASK FOR A BRIEF
- DISCUSS COMPENSATION
- STAY CALM & LISTEN
- HAVE A BACKUP PLAN
- MAKE SOMETHING GREAT
- IT'S OKAY TO SAY NO

BE HUMAN

NO MATTER YOUR
INDUSTRY, YOUR FRIENDS
& FAMILY ARE GOING TO
ASK YOU FOR STUFF.
WHETHER IT'S FULL
PROJECTS, COLLABORATION
OR "JUST A QUICK THING,"
IT'S GOING TO HAPPEN.
REMEMBER THAT THIS
IS A PERSON IN YOUR
LIFE! BE HUMAN.

SET CLEAR BOUNDARIES

BE UP FRONT ABOUT WHAT IS ACCEPTABLE & WHAT ISN'T. BE UP FRONT ABOUT THE TIME YOU HAVE, WHAT YOU CAN & CANNOT COMMIT TO & HOW MANY PHONE CALLS ARE TOO MANY PHONE CALLS. ALSO, YOU ARE NOT WWW.GOOGLE.COM THE WEBSITE.

ASK FOR A BRIEF

CLIENTS PRESENT BRIEFS
OR PROJECT OUTLINES
TO HIRE YOU, SO FRIENDS
& FAMILY SHOULD BE NO
DIFFERENT. HELP THEM
BREAK DOWN COMPLEX
IDEAS INTO A GUIDE-
LINE YOU CAN BOTH
FOLLOW EASILY. THIS
WILL ALSO HELP
DEFINE A LEVEL OF
PROFESSIONALISM TO BE
MAINTAINED BY YOU BOTH.

DISCUSS COMPENSATION

WHETHER YOU'RE OFFERING THE "FRIEND RATE" OR DOING A FAVOR FOR THE PERSON WHO BIRTHED YOU INTO THIS WORLD (INFINITE INTANGIBLE VALUE) IT'S IMPORTANT TO OPENLY TALK ABOUT FAIR COMPENSATION. DO THIS EARLY ON TO AVOID SURPRISES OR RESENTMENT.

STAY CALM & LISTEN

THERE'S NOTHING QUITE LIKE THE BASELESS RAGE WE CAN FEEL TOWARD THE PEOPLE WE LOVE OVER EXTREMELY PETTY ~~SHIT~~. BUT YOU CAN'T TALK OVER OR YELL AT A CLIENT. HOLD YOUR END OF THE BARGAIN BY LISTENING FIRST & THEN GENTLY OFFERING YOUR SUGGESTIONS OR GUIDANCE.

HAVE A BACKUP PLAN

SOMETIMES THINGS JUST GO SOUR. YOUR CONTRACTS WITH CLIENTS PROBABLY HAVE A KILL FEE, SO THIS NEW CLIENT SHOULD BE NO DIFFERENT. AGREE ON WHAT HAPPENS IF THINGS FALL THROUGH, A COLLABORATION DOESN'T STICK, OR A PARTNER WANTS OUT.

MAKE SOMETHING GREAT

LET'S NOT FORGET THE POSITIVES! WORKING WITH PEOPLE YOU ALREADY KNOW & UNDERSTAND CAN BE AMAZING. YOUR EXISTING RELATIONSHIP & EASY EXCHANGE OF IDEAS MIGHT RESULT IN SOME TRULY MAGICAL CREATIVE ENERGY & BRING YOU CLOSER. HAVE AS MUCH FUN AS YOU CAN.

IT'S OKAY TO SAY NO

ULTIMATELY, WORK IS WORK. IT IS ALWAYS OKAY TO TURN DOWN A PROJECT BECAUSE YOU DON'T HAVE TIME, RESOURCES, OR, YOU KNOW, THE DESIRE TO DO IT. THIS MIGHT BE A GREAT OPPORTUNITY TO PASS A JOB ALONG TO SOMEONE ELSE IN YOUR CREATIVE COMMUNITY. WEIGH YOUR OPTIONS!

One of the hardest things about being a "working creative" is finding your style. It's tempting to learn by identifying what you like and reiterating it until it's yours, but is that really the most honest? Do you want to be someone who is keeping up, or someone who is leading their own way?

By now you've spent a good portion of your life learning things about yourself, steering those things in different directions, hiding them, claiming new identities and any number of other adjustments we all make (consciously or not). So maybe, just as an exercise, let's try to look objectively at our guts and then trust them.

Life is going to tell you a lot of things about yourself that you didn't ask to be told. Negativity will be thrown at you out of nowhere. But when you're being true to yourself and doing what you love, none of that really matters. We know this, but it bears repeating: Love conquers hate and never giving up is how you win.

HOW TO BE YOURSELF

- WHO THE ~~F*ck~~ ARE YOU?
- IDENTIFYING YOUR TRUTH
- WHO DO YOU WANT TO BE??
- LOVING EVERY PART
- FINDING YOUR VOICE
- BUILDING YOUR WORLD
- USING YOUR POWER
- LETTING OTHERS IN

WHO THE ~~FUCK~~ ARE YOU?

BEFORE YOU CAN CREATE
& SHARE HONEST WORK
WITH THE WORLD, YOU
NEED TO HAVE A SENSE
OF WHERE IT COMES FROM.
YOU CAN STAY BUSY
MAKING ~~SHIT~~ BLINDLY,
OR YOU CAN LOOK INWARD.
WHO ARE YOU & HOW
DOES THAT INFORM
WHAT YOU DO?

IDENTIFYING YOUR TRUTH

WHAT MAKES YOU WHO YOU ARE? YOU MAY HAVE BEEN TOLD THAT THIS CORE TRUTH IS SOMETHING TO FEAR OR BE ASHAMED OF. THAT IS NOT TRUE. WHAT'S TRUE IS THE EXPERIENCE YOU BRING & THE HEART OF THE REAL, HUMAN PERSON THAT YOU ARE.

WHO DO YOU WANT TO BE?

WE ALL CHANGE, SO PRETENDING OTHERWISE IS SILLY. THINK ABOUT WHO YOU HOPE TO GROW INTO. THAT DESIRE IS AS IMPORTANT AS WHO YOU ARE CURRENTLY, TO SET YOUR INTENTION & INFORM THE STEPS YOU'LL TAKE NOW TO GET THERE.

LOVING EVERY PART

IT CAN BE HARD TO EMBRACE THE ROOTS WE'VE BURIED DEEP, BUT TAKE TIME TO INSPECT THEM. THIS IS WHAT HAS LED TO YOUR OUTLOOK & THE HUMANITY OF YOUR CREATIVE WORK.

LEARN TO CHERISH (OR AT LEAST ACKNOWLEDGE) EVEN YOUR DARKEST PARTS.

FINDING YOUR VOICE

MAYBE DON'T SHOUT YOUR SECRETS, BUT DO LEARN TO SPEAK FROM THAT PLACE OF HONESTY. TRY TO CREATE WORK THAT EVOKES TRUE EMOTION FROM YOUR EXPERIENCE, BUT WITHOUT MAKING IT COMPLETELY INACCESSIBLE TO OTHERS. SOME MIGHT CALL THIS #RELATABLE CONTENT.

BUILDING YOUR WORLD

YOU BUILD YOUR "BRAND" (OR LIKE, ACTUAL BRAND) THROUGH A COMBINATION OF STORY & MISSION.

CREATE PROJECTS THAT BUILD ON EACH OTHER WHILE REFLECTING THAT FUTURE-SELF YOU HOPE TO BE. THIS BECOMES YOUR BODY OF WORK & PART OF WHO YOU ARE.

USING YOUR POWER

YOUR COMBINATION OF HISTORY, VOICE & SKILL CAN BE HARNESSED TO DO INCREDIBLE THINGS. YOU ARE A GIFT.

TECHNOLOGY ENABLES US TO ACCOMPLISH SO MUCH WITH EVEN LIMITED RESOURCES. SOMETIMES YOU JUST NEED TO TRY FIRST & WORRY LATER.

LETTING OTHERS IN

EVEN WHEN YOU LOVE
& FIND POWER IN YOUR
OWN VOICE, IT CAN BE
TERRIFYING TO SHARE IT.
TRUST THAT YOU ARE THE
EXACT THING THAT
SOMEONE NEEDS. IT MAY
TAKE TRIAL & ERROR,
BUT YOU WILL FIND YOUR
PERFECT COLLABORATOR
& CAN SUCCEED
TOGETHER.

We've all faced difficult challenges before. Part of being someone who is actively engaged with their creativity is finding smart solutions to whatever problems come our way. This is especially true when you own your business (full-time or side-hustle) and ultimately have to count on yourself to get through. But sometimes—maybe even right now—you are faced with the kind of challenge that makes you question everything.

Giving up completely isn't a real option. Shutting down is just delaying the inevitable. Feeling helpless is valid, until you need to pull yourself together again.

Life moves forward whether you're ready or not, so it's our job to keep moving too. It won't happen overnight, but change will come. Here's my advice on how to keep going, so you'll still be here when it does.

HOW TO KEEP GOING

- IT WILL BE HARD
- BE TRUE TO YOURSELF
- ADAPT & CHANGE
- BE RESOURCEFUL
- REDEFINE SUCCESS
- RAISE EACH OTHER UP
- CREATE & PRESERVE SPACE
- DON'T EVER STOP

IT WILL BE HARD

BEING A PERSON IN THE WORLD ISN'T EASY. YOU MAY FEEL PRESSURE TO QUIT FROM OUTSIDE YOUR CIRCLES & PRESSURE FROM WITHIN THEM TOO. BUT WE DIDN'T CHOOSE THIS BECAUSE IT'S EASY. WE CHOSE IT BECAUSE IT'S WHO WE ARE. IT WILL SEEM LIKE YOU HAVE GONE AS FAR AS YOU CAN GO. GO FURTHER.

BE TRUE TO YOURSELF

WHILE OTHERS MAY HAVE SIMILARITIES, ONLY YOU ARE YOU. THERE'S NO NEED TO SOFTEN OR PLACATE OR COMPROMISE. BE PERSONAL, RAW & PASSIONATE. BE THAT TRUE SELF AS LOUD AS YOU CAN TO DROWN OUT ANY VOICES TRYING TO SILENCE YOU, INCLUDING YOUR OWN.

ADAPT & CHANGE

PART OF BEING YOURSELF IS KNOWING THAT YOU WILL GROW. ENCOURAGE YOURSELF TO DO SO THOUGHTFULLY. LIFE MOVES ON, CULTURE SHIFTS & YOU CAN'T SUCCEED IF YOU DON'T STAY INFORMED, AWARE & MALLEABLE. PART OF STAYING ON TARGET IS KNOWING WHEN TO REFOCUS.

BE RESOURCEFUL

YOU HAVE ACCESS TO
RESOURCES TODAY THAT
DIDN'T EXIST AS RECENTLY
AS 5 YEARS AGO. STAY
UP TO DATE WITH ADVANCES
IN TOOLS & TECHNOLOGY
SO THAT YOU CAN
INCORPORATE NEW METHODS
INTO YOUR PRACTICE.
THE THING YOU'VE NEEDED
ALL ALONG MAY NOT
HAVE EXISTED UNTIL
RECENTLY.

REDEFINE SUCCESS

SUCCESS IS NOT ABOUT WINNING THE HEARTS OF EVERY PERSON. FOCUS ON THE PEOPLE WHO WILL UNDERSTAND, BENEFIT FROM & SUPPORT YOU. IF YOU COULD WIN OVER EVEN 5% OF THE WORLD, THAT'S STILL 370 MILLION PEOPLE & A TREMENDOUS SUCCESS. FOCUS ON THE POSSIBLE.

RAISE EACH OTHER UP

YOU ARE ON YOUR OWN JOURNEY, BUT YOU ARE NOT ALONE. EACH OF US IS FIGHTING TO BE HEARD IN A CHORUS OF OVERLAPPING & INTERSECTING VOICES. SUPPORT EACH OTHER'S WORK, WORDS, PROJECTS & PRODUCTS. WE ALL WIN WHEN WE HELP EACH OTHER SUCCEED.

CREATE & PRESERVE SPACE

THE WORLD IS NOT JUST HANDING OUT SAFE SPACES WHERE WE CAN MAKE, GROW & FLOURISH. WE CAN HELP EACH OTHER BY CREATING BOTH PHYSICAL & DIGITAL SPACES THAT SUPPORT EACH OTHER. MORE IMPORTANT, WE CAN WORK TOGETHER TO PRESERVE THOSE THAT ALREADY EXIST.

DON'T EVER STOP

DON'T STOP BEING YOURSELF. DON'T STOP SPEAKING OUT. DON'T STOP FIGHTING TO BE HEARD. DON'T STOP MAKING WORK THAT MATTERS. DON'T STOP SHOUTING, WHETHER THAT'S BY LITERALLY SHOUTING OR SIMPLY LIVING YOUR LIFE YOUR WAY. NEVER GIVING UP IS HOW YOU WIN. NEVER GIVE UP. WIN.

A lot of what we want for ourselves and our careers comes down to "success." We want to succeed, we want to win, we want to be perceived as having "made it" by others. So much about success is discussed in finite terms like "landed a gig" or how someone "has finally arrived." So if success is this tangible, ownable, achievable thing, how do we get there?

There is no shortage of books offering the secrets to success in all sorts of specific areas, or life in general. This book ends where it began, with the eight "Simple Tips for Success" that inadvertently launched a monthly column, became this book, and signaled a shift in how I think about myself and my own work.